This little book
of pleasant thoughts
belongs to

Mary Grace Adams
from Ruby Sutton

April, 1995.
Many of the thoughts
remind me of you.

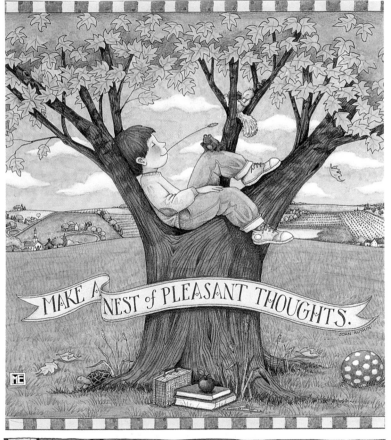

MAKE A NEST of PLEASANT THOUGHTS.
—JOHN RUSKIN

Life Is Just a Chair of Bowlies

by
Mary Engelbreit

Andrews and McMeel
A Universal Press Syndicate Company
Kansas City

10 9 8 7

ISBN: 0-8362-4604-7

Library of Congress Catalog Card Number: 91-78254

Life Is Just a
Chair of Bowlies

Any day is sunnier
that's brightened by a smile...

EVERYONE NEEDS THEIR OWN SPOT.

· ROBERT WHALEN ·

Any friendship blossoms
if it's tended to with style...

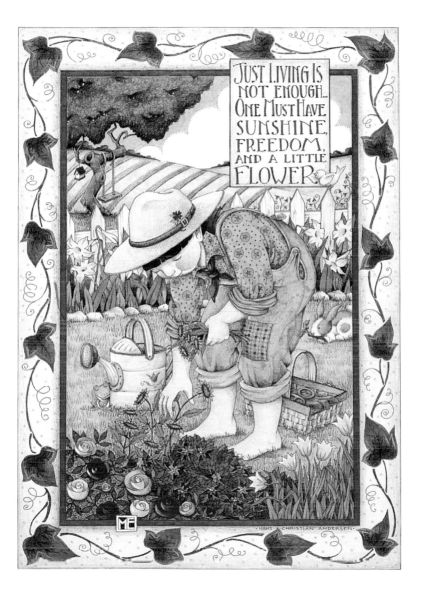

JUST LIVING IS NOT ENOUGH... ONE MUST HAVE SUNSHINE, FREEDOM, AND A LITTLE FLOWER.

·HANS CHRISTIAN ANDERSEN·

Any landscape's fresher
from a broader point of view...

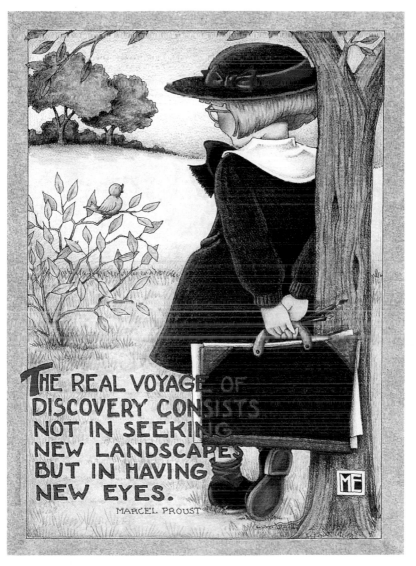

THE REAL VOYAGE OF DISCOVERY CONSISTS NOT IN SEEKING NEW LANDSCAPES BUT IN HAVING NEW EYES.

MARCEL PROUST

Any learning's richer
when it's multiplied by two.

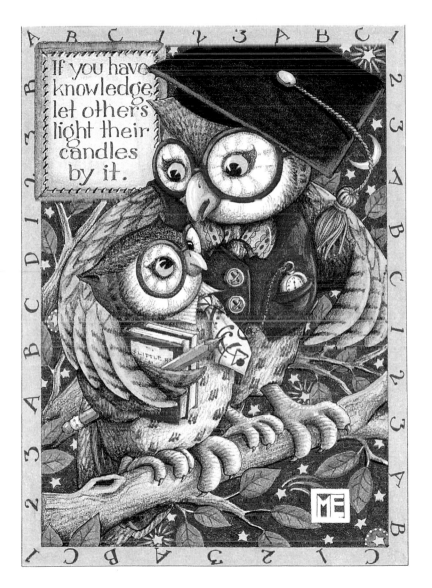

If you have knowledge, let others light their candles by it.

Sometimes all that's needed
is the willingness to try...

Seeing things more clearly
helps the time fly by!

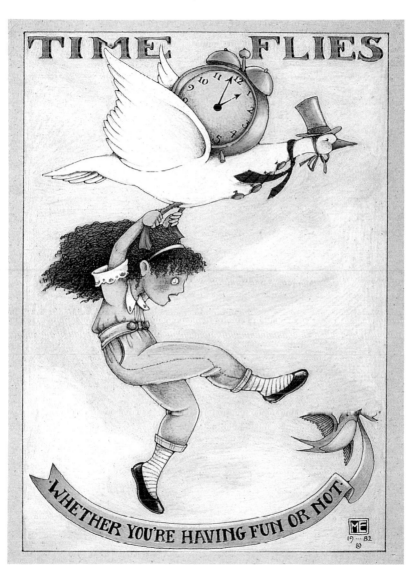

Being glad for what we've got
renews our confidence...

And standing up for what we think
makes a difference!

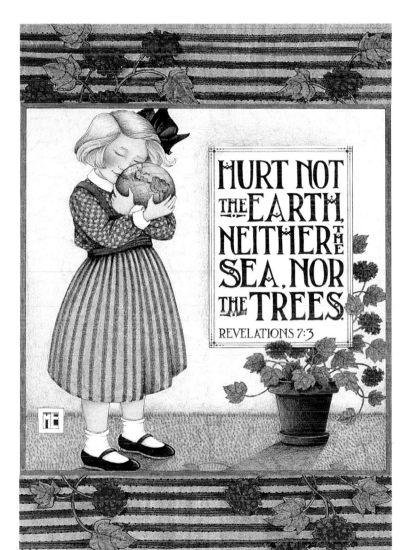

HURT NOT THE EARTH, NEITHER THE SEA, NOR THE TREES.

REVELATIONS 7:3

If we lose direction...

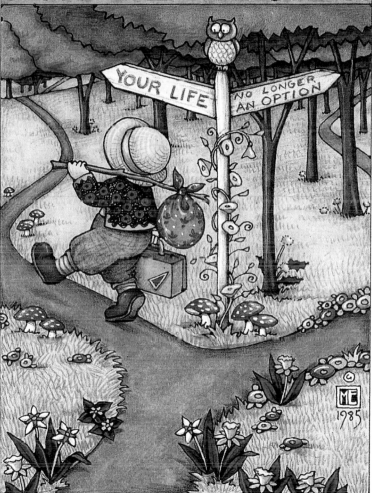

or are sometimes feeling low...

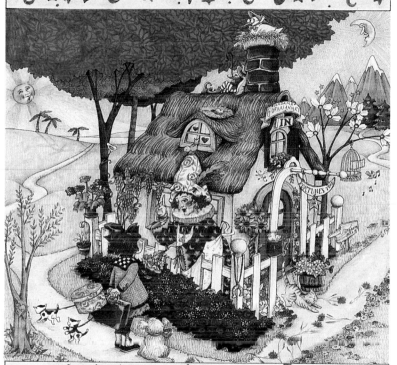

REMEMBER...
No Matter Where You Go...

There You Are.

we should concentrate on others
and try to let them know...

SOW GOOD SERVICES;
SWEET REMEMBRANCES
WILL GROW FROM THEM.

Mde. de Stael.

for every goodness given
returns a hundredfold...

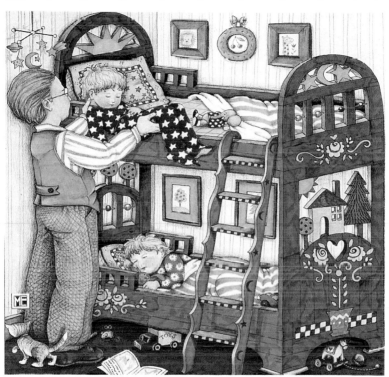

NOTHING IS SO STRONG AS
GENTLENESS;
NOTHING SO GENTLE AS
REAL STRENGTH.
FRANCIS DE SALES

...and no one knows the limit
of the joy a heart can hold!

WHO WELL LIVES, LONG LIVES;
FOR THIS AGE OF OURS
SHOULD NOT BE NUMBERED
BY YEARS, DAYS, AND HOURS.
— DU BARTES.

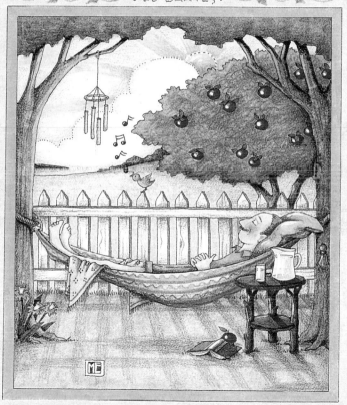

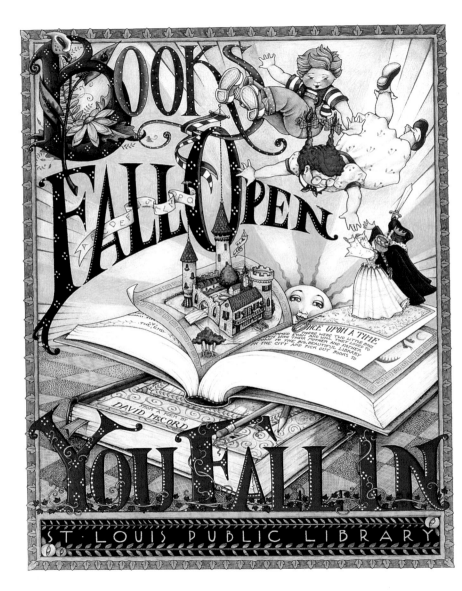

BOOKS
FALL OPEN

A B C D E F G H I J K L M N O P Q

ONCE UPON A TIME
THERE WERE TWO LITTLE BOYS
NAMED EVAN AND WILL. THEY
LIVED WITH THEIR MOTHER AND FATHER.
ONCE UPON A TIME, THEY TRAVELED TO
THE BIG, BEAUTIFUL LIBRARY
IN THE CITY AND PICK OUT BOOKS TO

THE END

FROM A POEM BY
DAVID McCORD

YOU FALL IN

ST · LOUIS · PUBLIC · LIBRARY